Midnigh

Kate Larsen is a graphic designer and illustrator based in Kent. She graduated from Ravensbourne College of Design and Communication in 2003 with a first in Visual Information Design. Kate's expertise lies in designing gift products, packaging and illustration, with a particular love of pattern. Whether she is working from her studio at home or meeting clients in London, Kate is often accompanied by her trusty whippet, Peanut.

Midnight Colouring

ANTI-STRESS ART THERAPY
FOR SLEEPLESS NIGHTS

KATE LARSEN

introduction by Richard Wiseman

BXTREE

First published 2016 by Boxtree
an imprint of Pan Macmillan
20 New Wharf Road, London N1 9RR
Associated companies throughout the world
www.panmacmillan.com

ISBN 978-0-7522-6592-6

1 3 5 7 9 8 6 4 2

A CIP catalogue record for this book is available from the British Library.

Printed and bound by Printer Trento S.r.l., Italy

Visit www.panmacmillan.com to read more about all our books
and to buy them. You will also find features, author interviews and
news of any author events, and you can sign up for e-newsletters
so that you're always first to hear about our new releases.

For Eva and Mae Larsen

introduction

For the past fifty years a small band of scientists have worked long into the night to uncover the mysteries of sleep. Their research has revealed that good quality sleep is vital for your psychological and physical well-being, and can even reduce the likelihood of heart attacks, some cancers, and obesity. Unfortunately, recent surveys have shown that we are now in the midst of an epidemic of sleeplessness, and that millions of people are failing to get a good night's sleep.

The main culprit is worry. People climb into bed feeling tense and then struggle to sleep because their mind is flooded with anxious thoughts. And the less they sleep, the more anxious they feel. Research shows that one of the best ways of breaking this vicious circle is to busy the mind with less threatening thoughts by, for example, counting backwards from one hundred in threes, or thinking of an animal for each letter of the alphabet ('A' is for 'ant', 'B' is for 'bear', and so on). This is all well and good, but it's not much fun. And that's where this book comes in.

Colouring is a really effective way of distracting your brain and relaxing your body. In addition, it can be carried out in low light, and is both satisfying and enjoyable. Because of this, it's perfect for improving your sleep. If you are struggling to fall asleep at the start of the night, spend about twenty minutes colouring – in low light – just before you head to bed. If you wake up in the middle of the night and lie awake for more than fifteen minutes, get out of bed (otherwise you will start to associate your bed with being awake) and, in low light, again spend twenty minutes colouring. It's as simple as that. Happy colouring, sleep well and sweet dreams.

Richard Wiseman

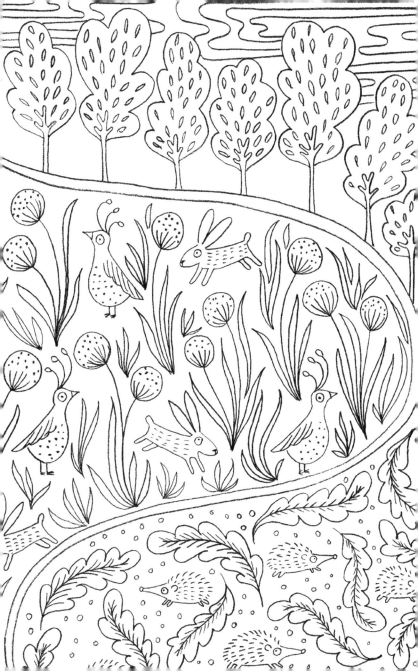

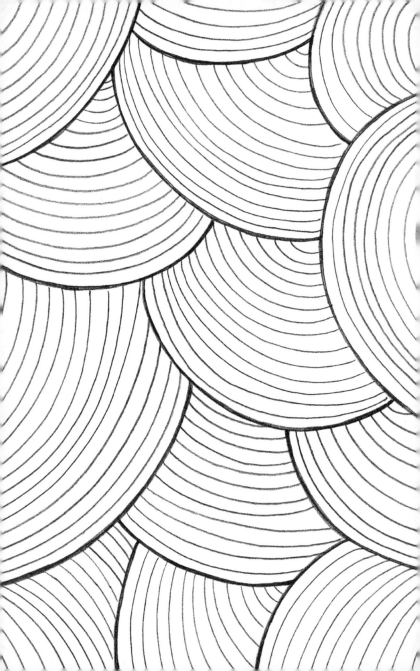

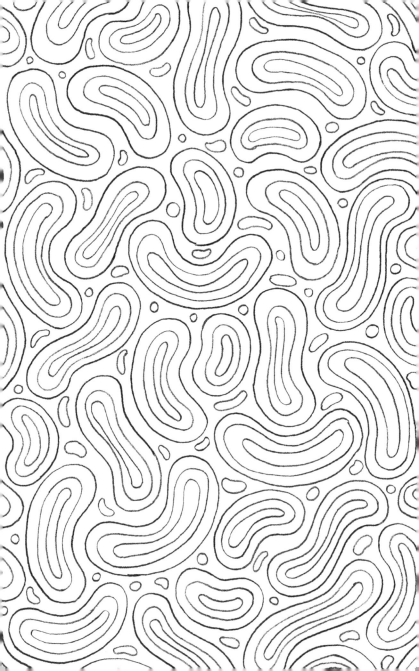

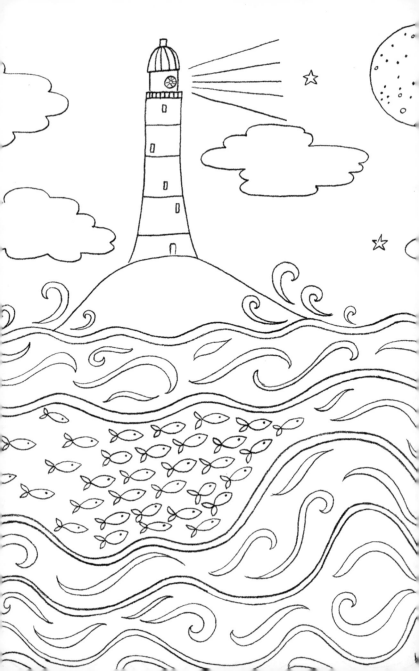

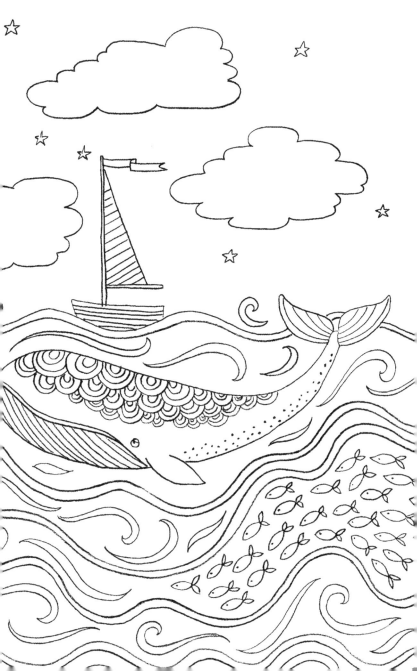

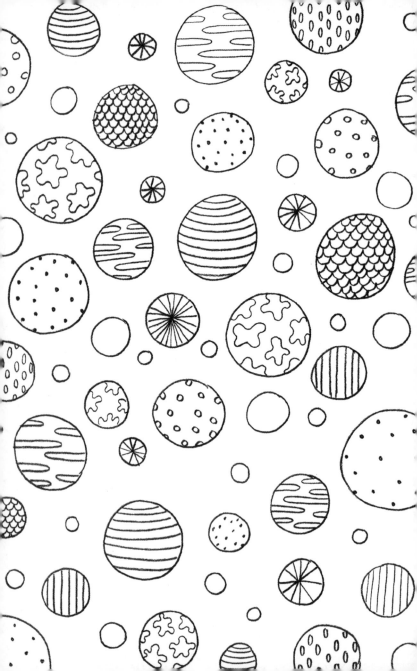

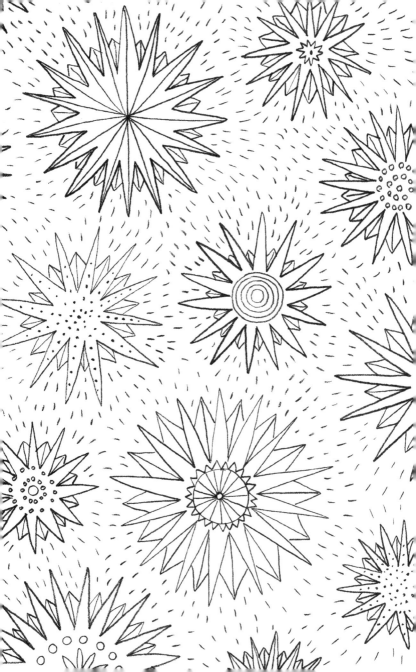

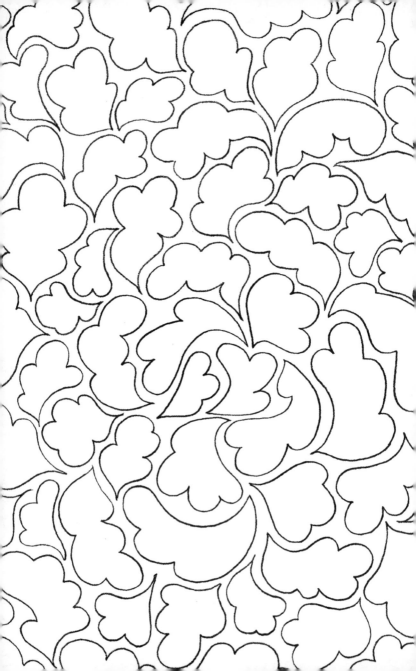

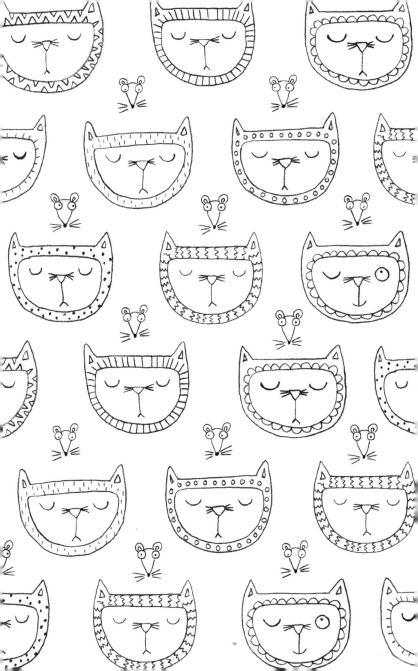

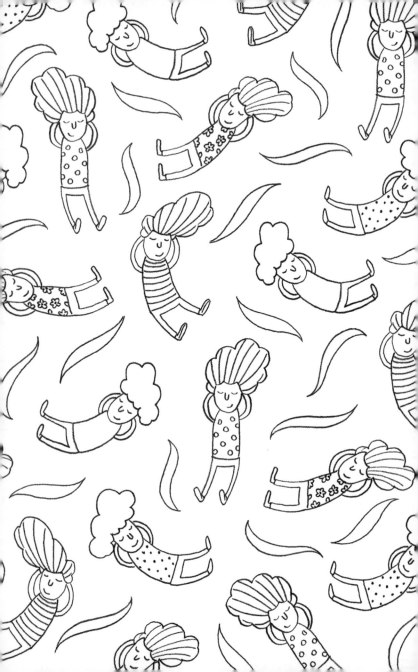

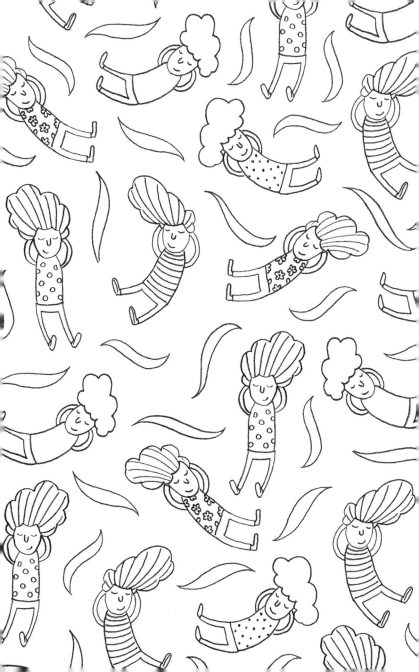

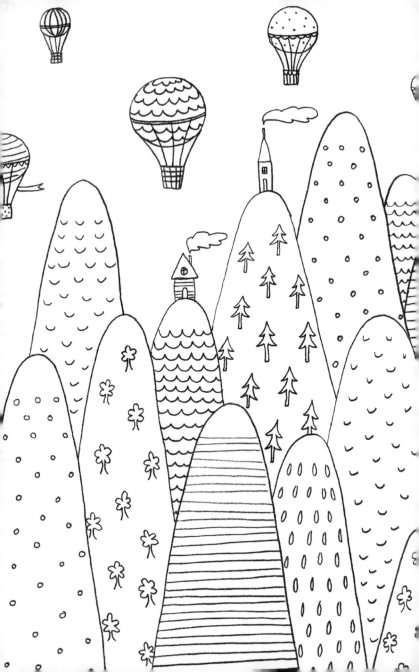

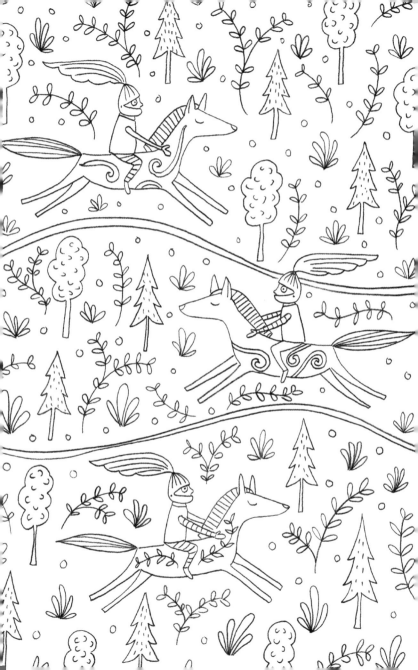

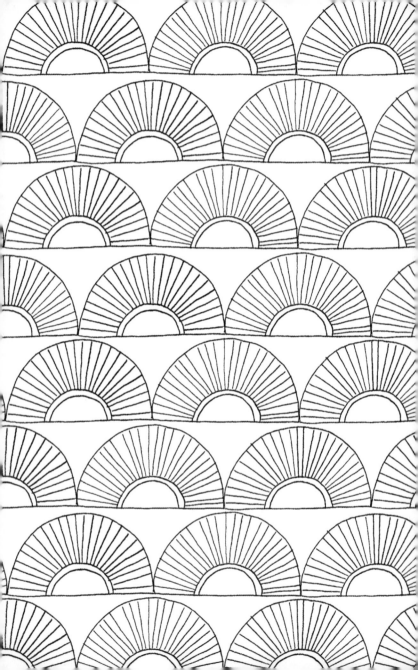

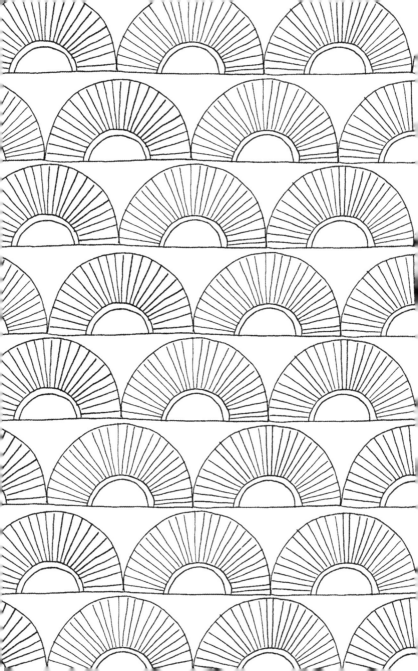

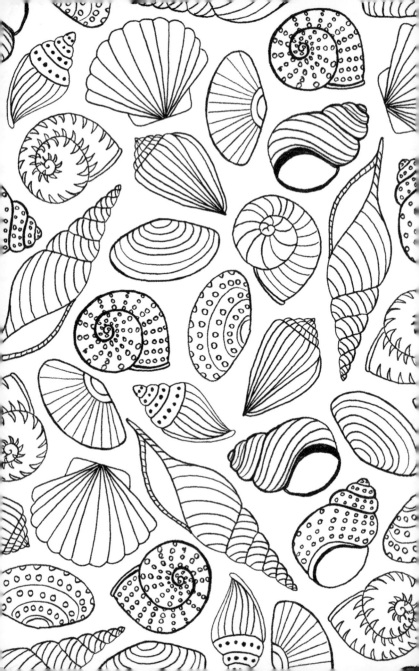

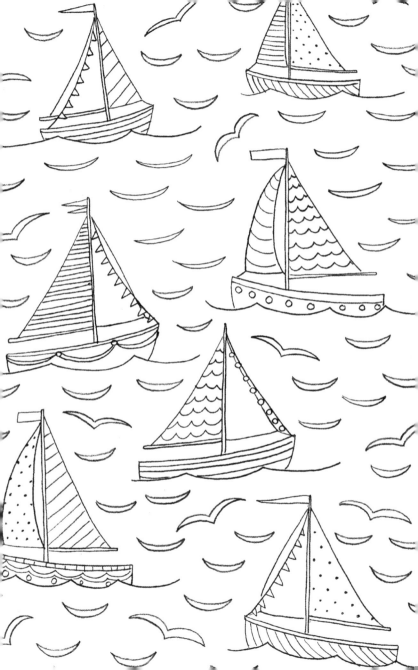

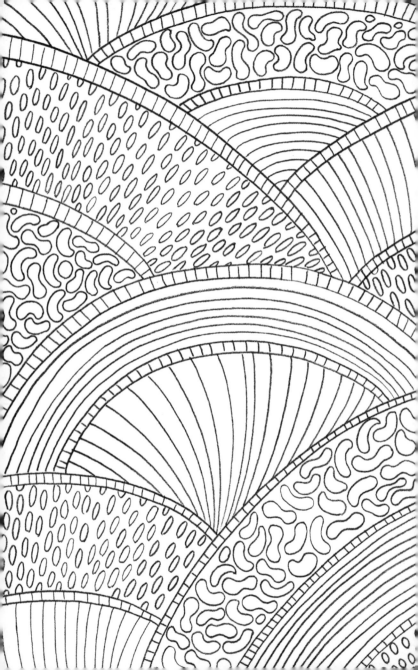

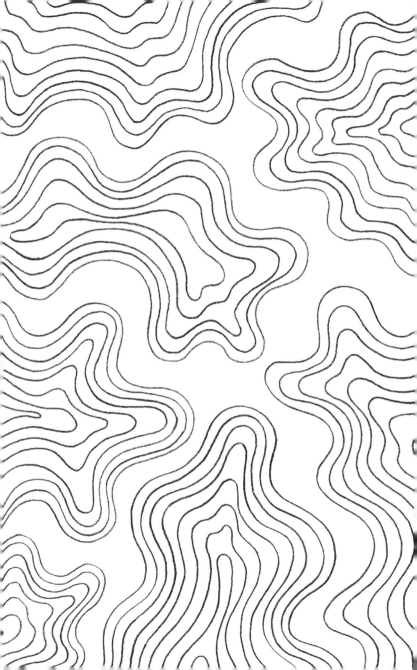

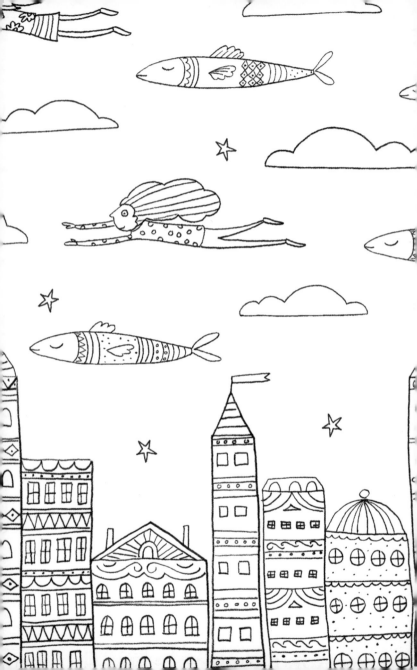

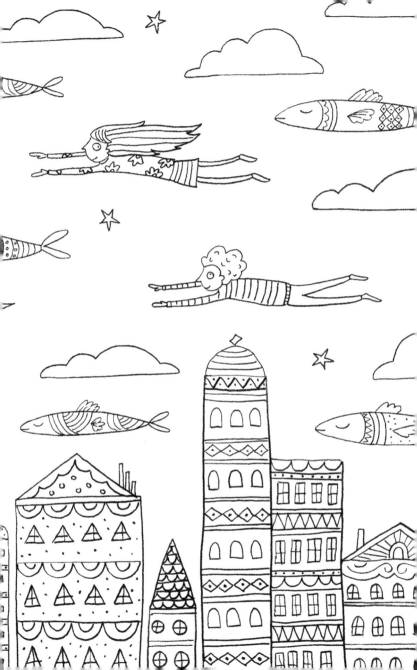

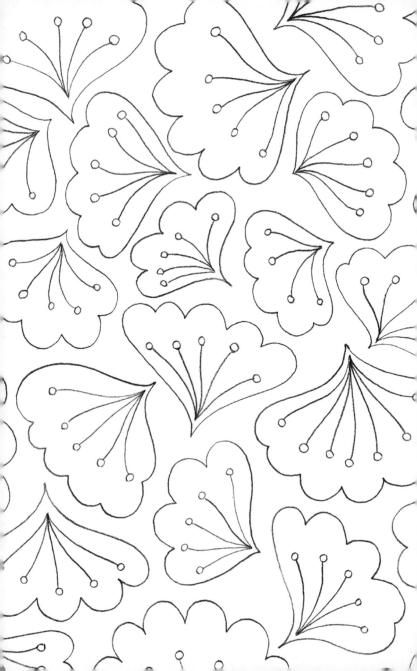

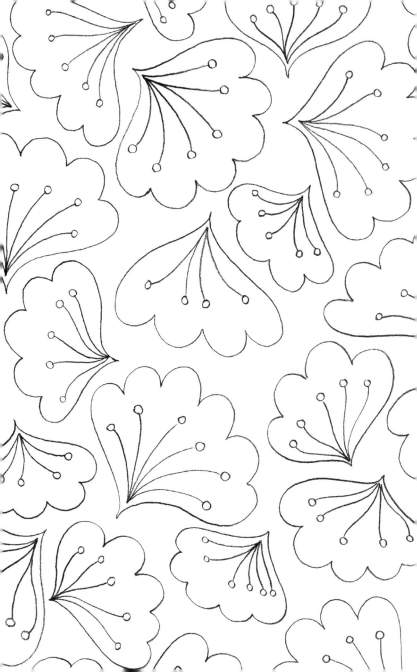

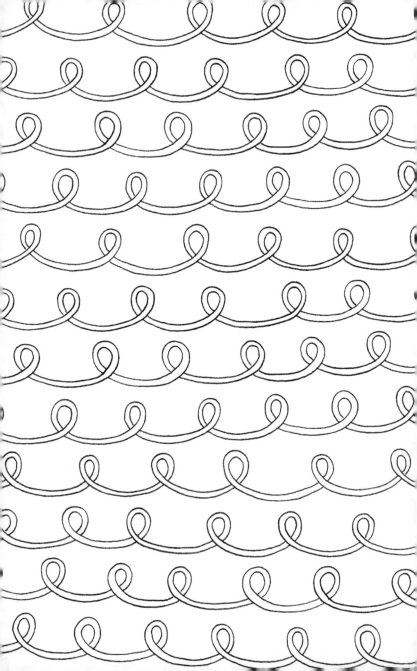

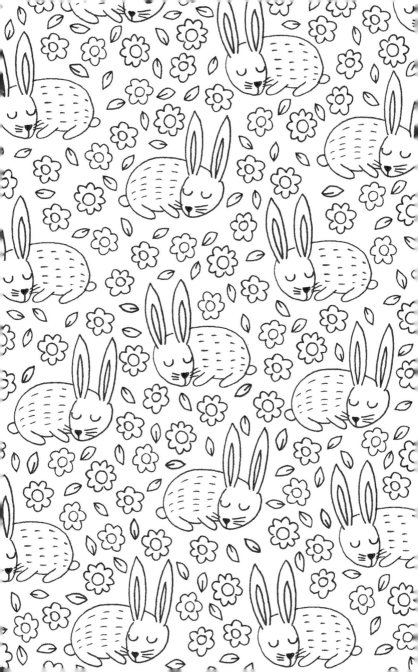

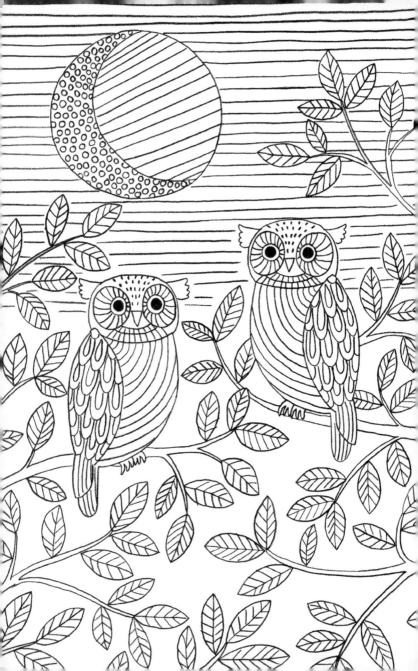

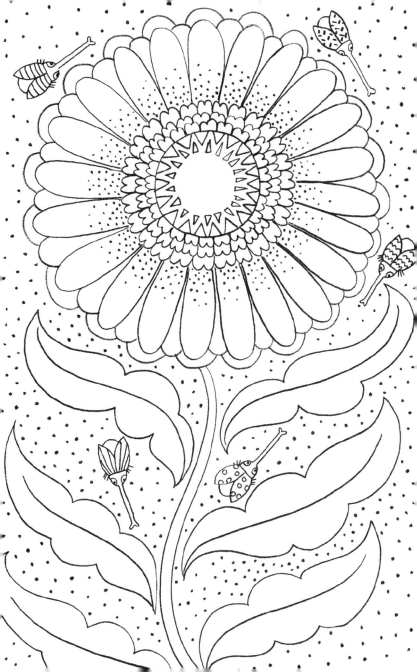

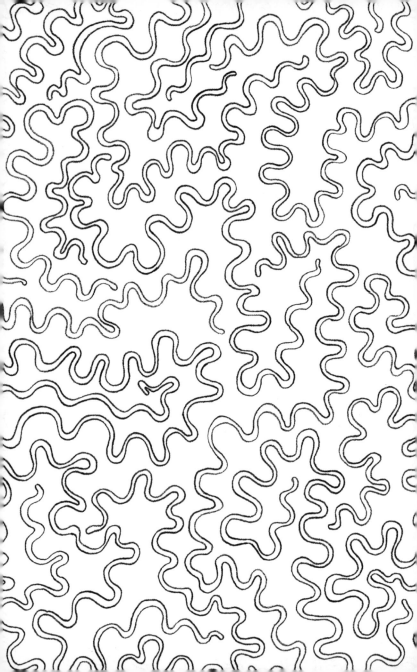

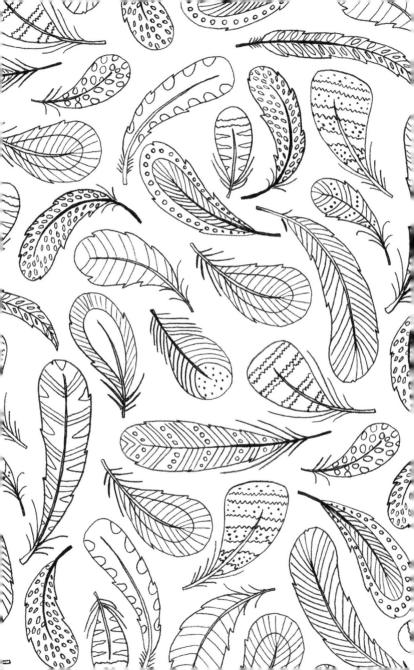

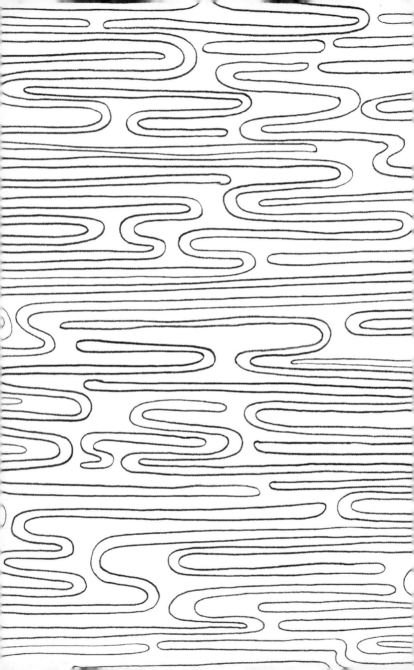

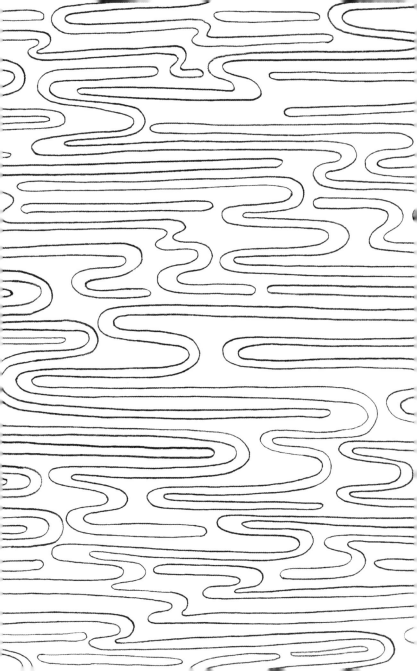

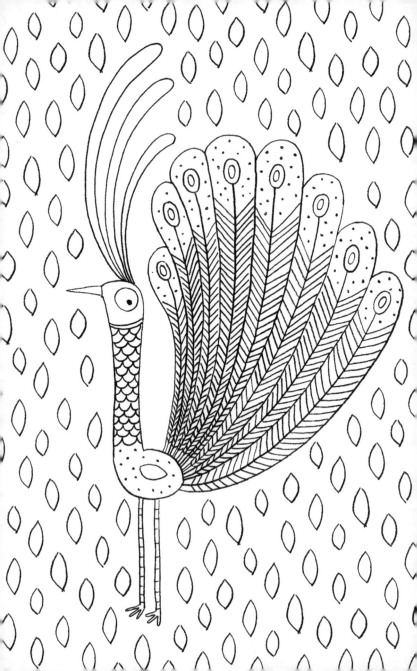

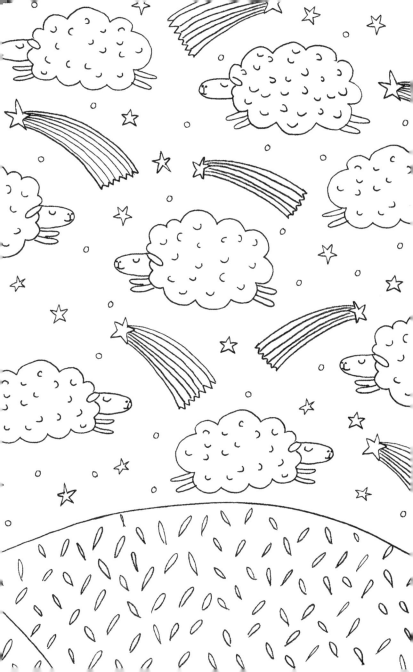

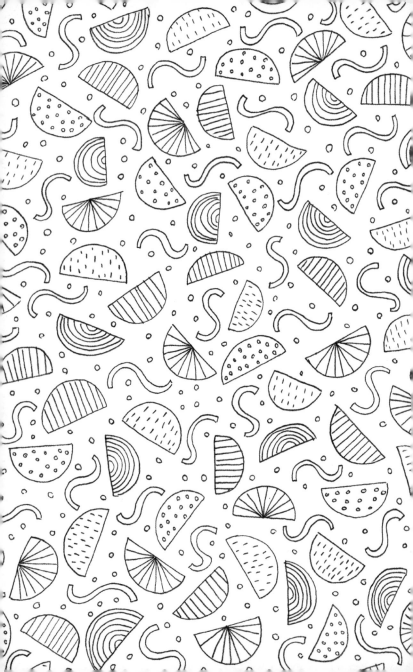

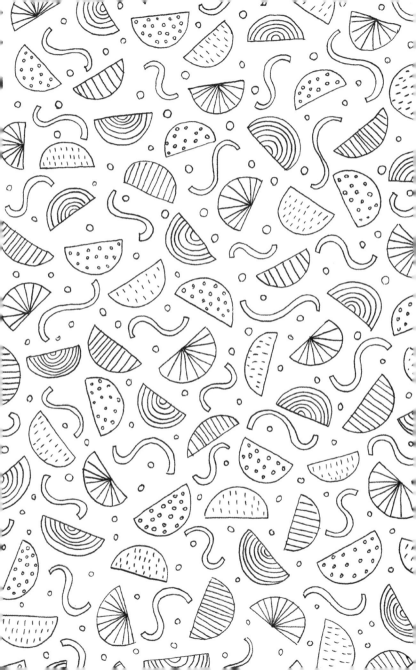

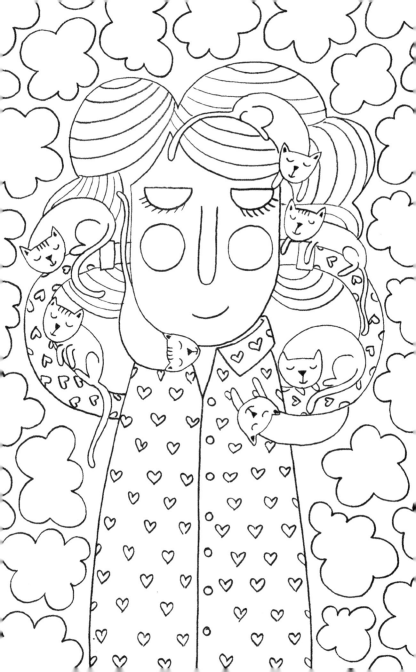

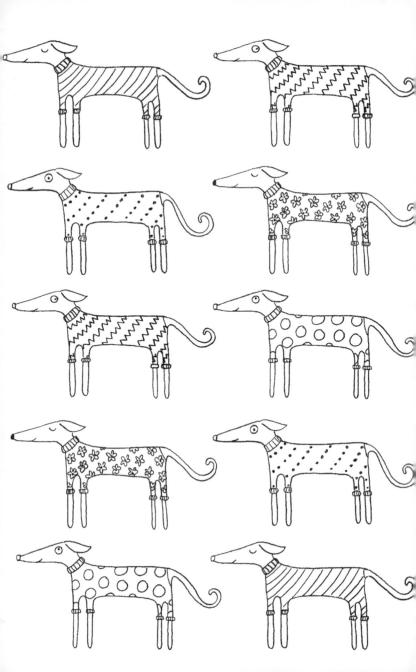

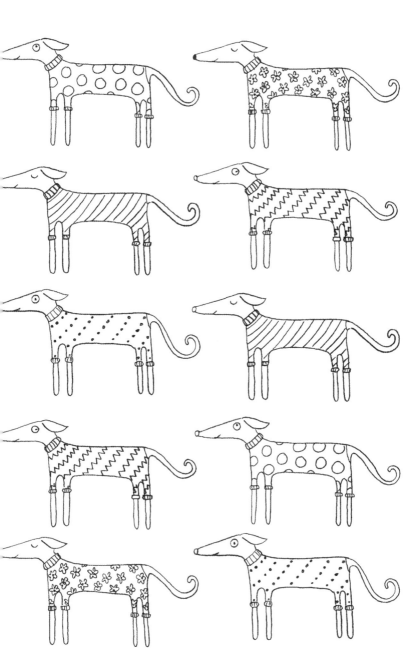

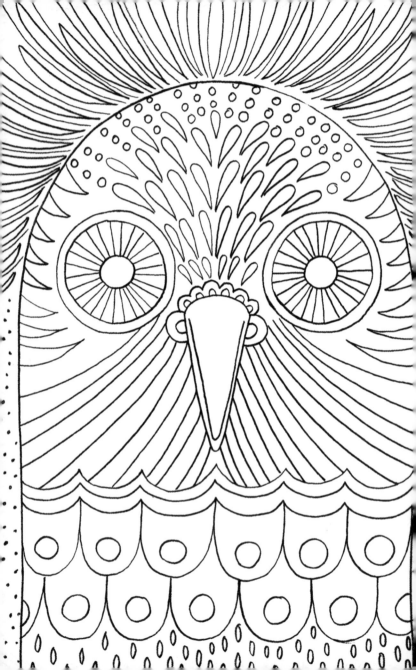

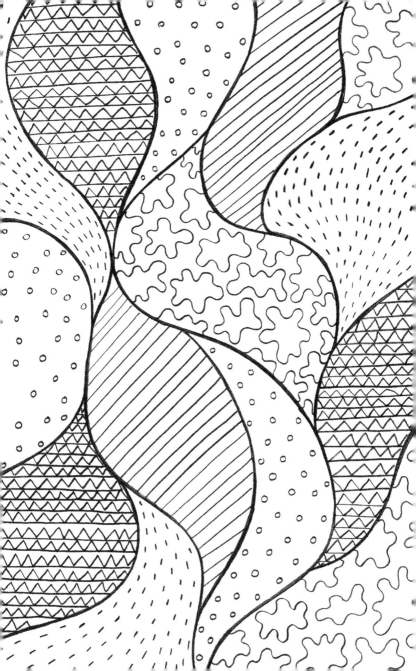

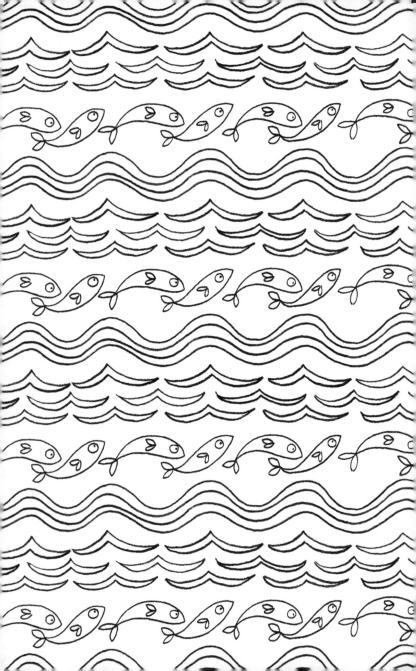

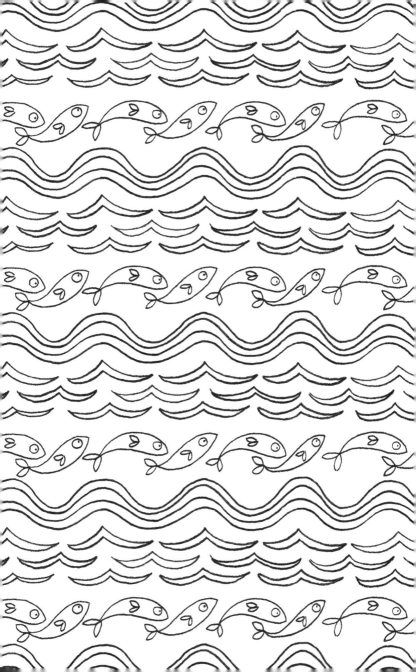

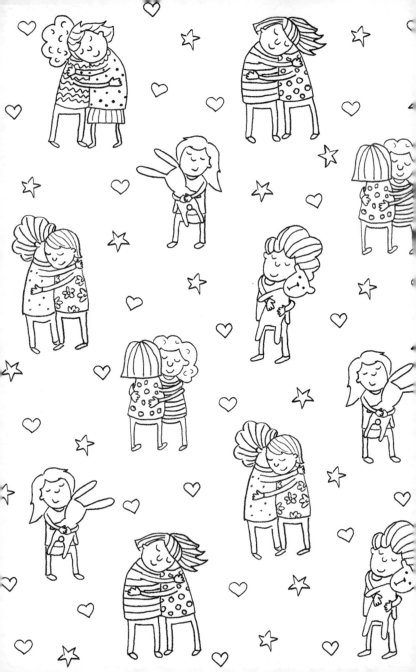

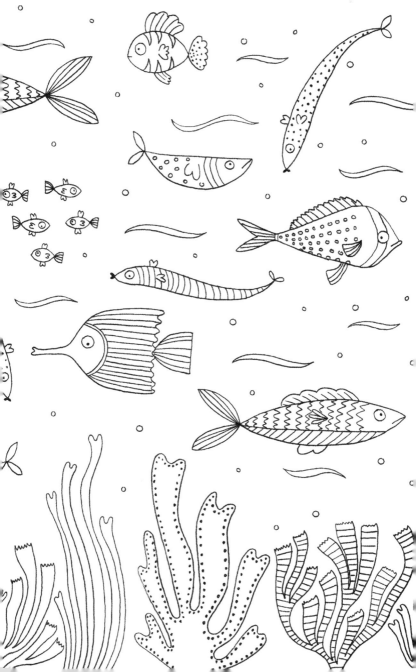

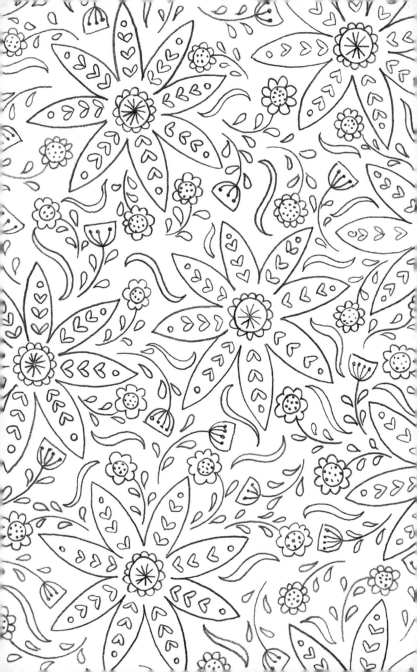

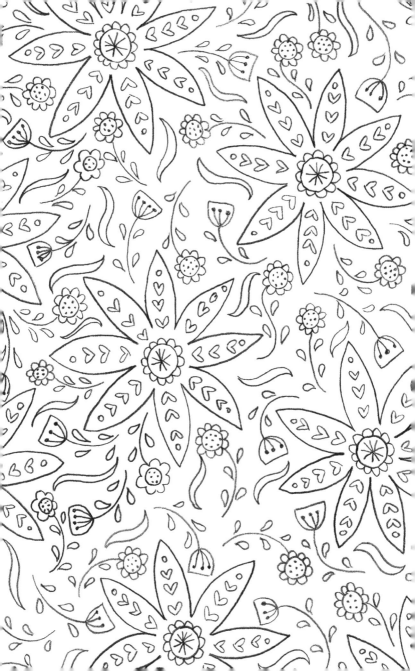

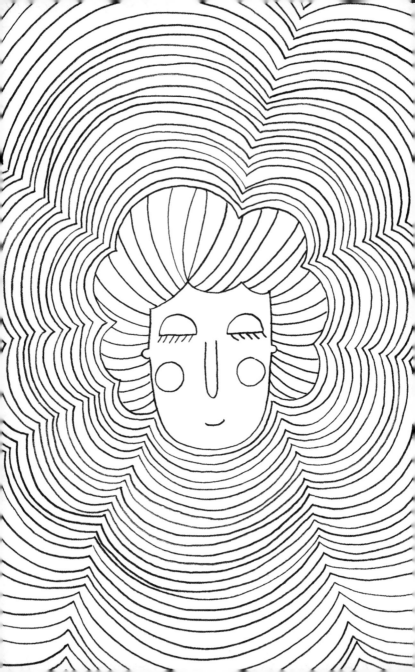

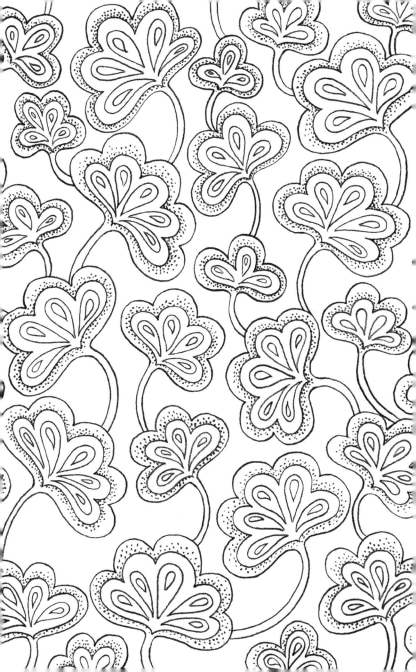

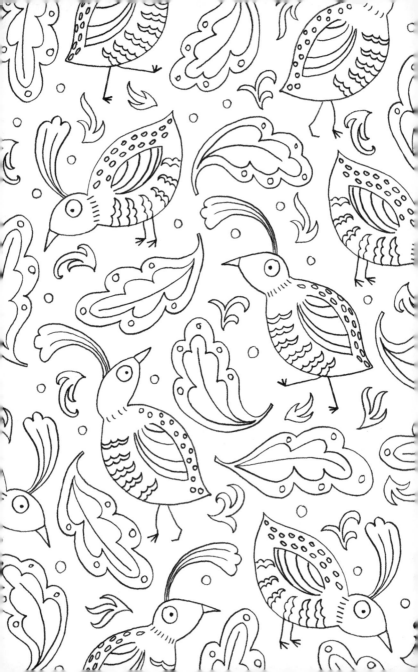

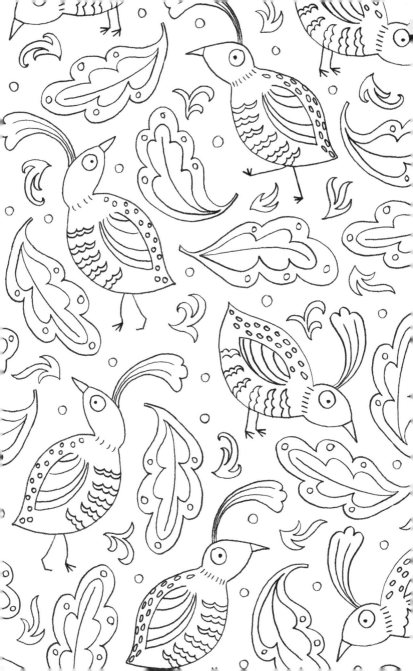

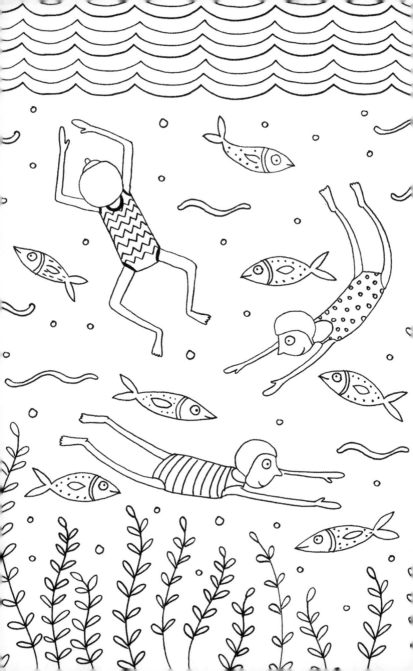

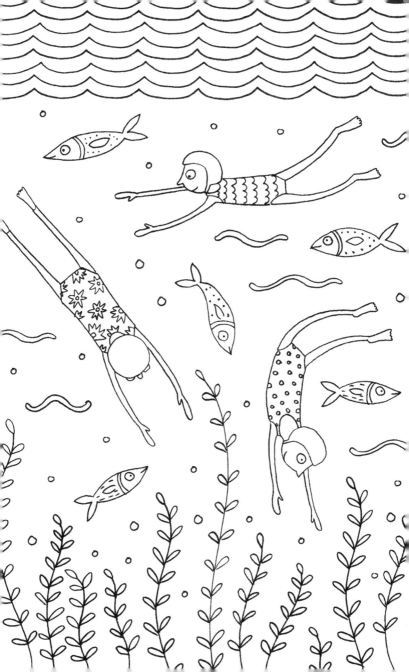

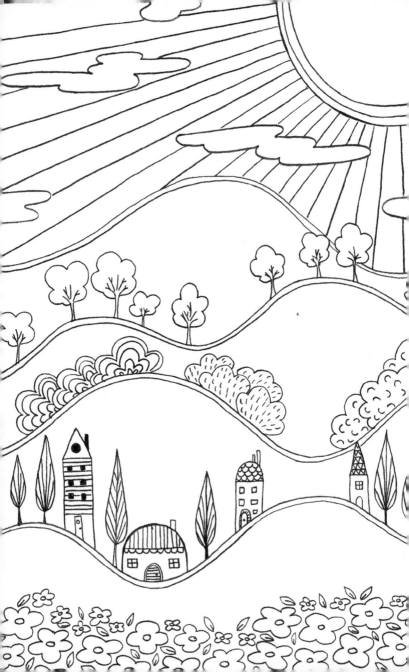

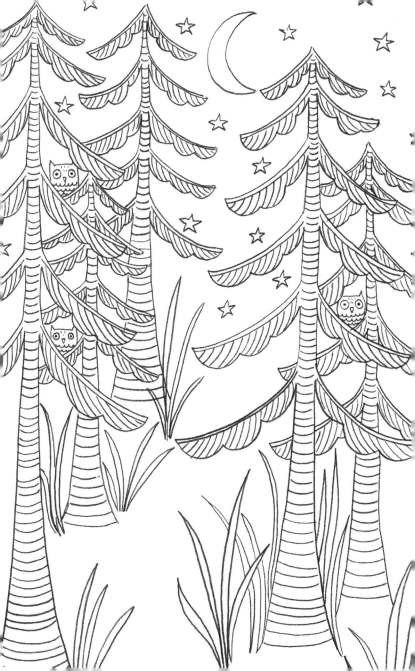

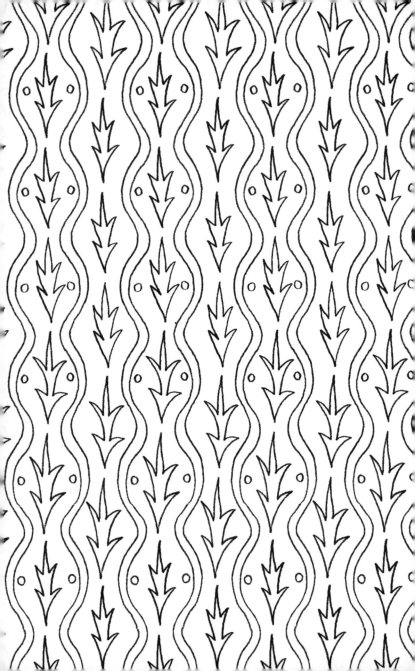

A big thank you to Nick Bentley,
and to Heidi Lightfoot and Katja Thielen
for being amazing as usual.